DUNDEE

HISTORY TOUR

First published 2018

Amberley Publishing
The Hill, Stroud,
Gloucestershire, GL5 4EP
www.amberley-books.com

Copyright © Brian King, 2018
Map contains Ordnance Survey data
© Crown copyright and database right
[2018]

The right of Brian King to be
identified as the Author of this work
has been asserted in accordance with
the Copyrights, Designs and Patents
Act 1988.

ISBN 978 1 4456 7825 2 (print)
ISBN 978 1 4456 7826 9 (ebook)

All images taken by the Author or from
the Author's personal collection.

British Library Cataloguing in
Publication Data.
A catalogue record for this book is
available from the British Library.

Origination by Amberley Publishing.
Printed in Great Britain.

ABOUT THE AUTHOR

Brian King was born and grew up in Dundee and has always had an interest in the changing face of the city. He attended the University of Edinburgh where he received an MA (Hons) in History. He currently works in Edinburgh as a searcher of public records and is still a regular visitor to Dundee.

INTRODUCTION

Dundee as we know it is traditionally said to have been founded in the late twelfth century by David, Earl of Huntingdon. Long before this, however, there had been a settlement in the area of modern Seagate, which was then on the water's edge. The nearby Black Rock (the site of St Paul's Cathedral today) provided the ideal location for Dundee's castle, which survived there until the early fourteenth century.

Over the years, Dundee grew into a thriving seaport and trading centre. In wake of the Industrial Revolution, this proved vital to the town's future. Local mills had grown up spinning linen, but when it was discovered that jute imported from the Indian subcontinent could be successfully spun when treated with whale oil, Dundee – with its port, mills and whaling fleet – had all the ingredients to become the capital of the jute industry.

The twentieth century saw traditional industries undergo a long, slow decline and Dundee adapted itself to a changing world. The 1960s and 1970s saw a rush to create a modern city that seemed to take little account of the past and saw the separation of the city centre from the River Tay as the approach roads to the new Tay Road Bridge replaced the central docks.

This bright new future, however, did not last as long as its proponents had anticipated and the early years of the twenty-first century have seen the disappearance of much of their vision. Dundee today is once again undergoing a period of transition. This time, though, the redevelopment is both forward-looking and sympathetic to the city's past, having provided a major new tourist attraction in the shape of the V&A Museum, but also managed, at last, to restore the link between Dundee and the river that helped bring it into being.

KEY

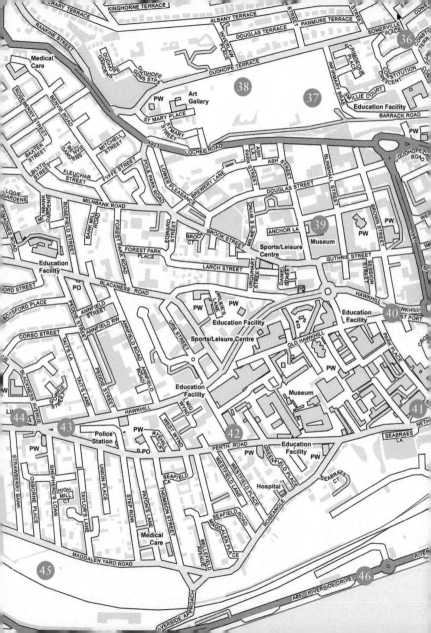

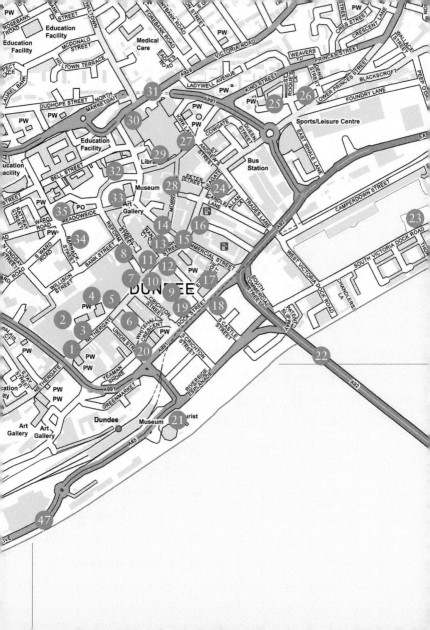

1. NETHERGATE

Originally known as the Fluckergait, the Nethergate (meaning 'lower way') stretches from the High Street to the Perth Road. The inner ring road has sliced through it at a point just to the right of St Paul's Church, destroying the street's once seamless progression and splitting it into two distinct sections. This photograph can be dated prior to 1936 when the Green's Playhouse with its distinctive art deco tower was opened.

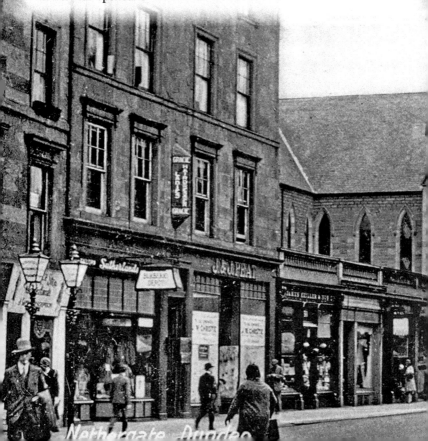

Nethergate, Dundee

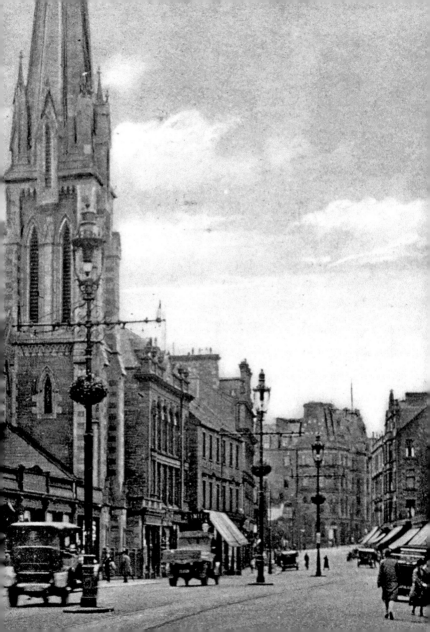

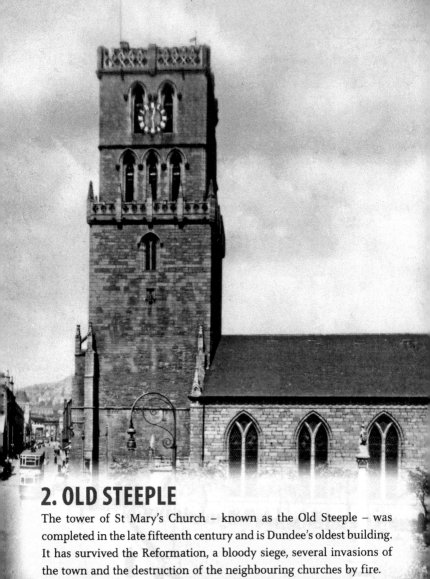

2. OLD STEEPLE

The tower of St Mary's Church – known as the Old Steeple – was completed in the late fifteenth century and is Dundee's oldest building. It has survived the Reformation, a bloody siege, several invasions of the town and the destruction of the neighbouring churches by fire.

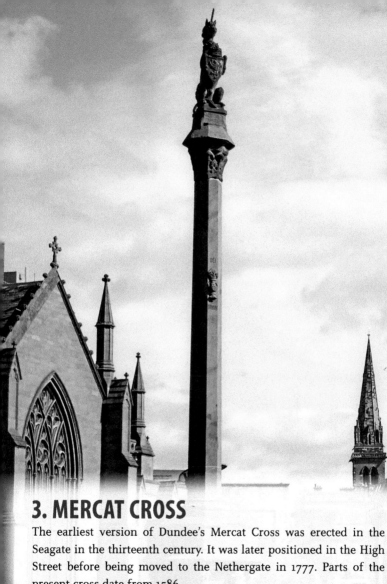

3. MERCAT CROSS

The earliest version of Dundee's Mercat Cross was erected in the Seagate in the thirteenth century. It was later positioned in the High Street before being moved to the Nethergate in 1777. Parts of the present cross date from 1586.

4. OVERGATE

This 1920s view is taken from the city square looking towards the Overgate. The round tower at the start of the Overgate itself (towards the right of the picture) was said to be General Monck's headquarters when he took the town for Oliver Cromwell in 1651. It stood until the 1960s, when it was demolished along with the surrounding buildings to make way for a new shopping centre, which has itself since been remodelled.

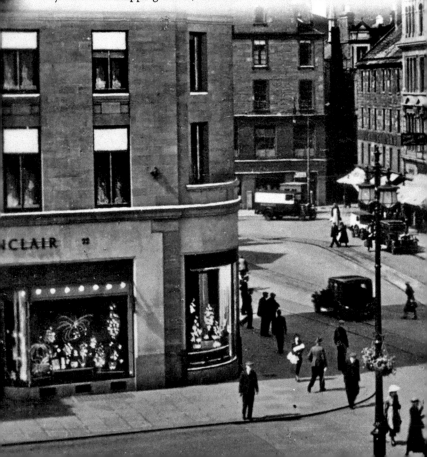

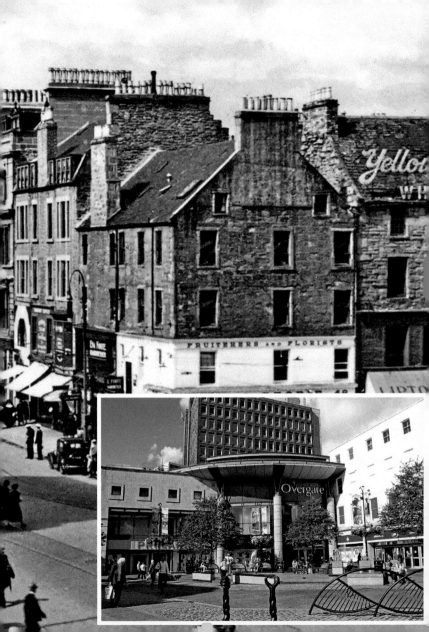

FRUITERERS AND FLORISTS

Yello
W H

Overgate

5. UNION HALL

Dating from the 1780s and originally known as the English Chapel, this building became known as the Union Hall after the departure of its episcopal congregation. It was demolished in the 1870s, but its former location can be determined with reference to the surviving building on the left (*see* inset). The twin-roofed building on the left of the earlier picture is Our Lady Warkstairs, built in the sixteenth century and demolished in 1879.

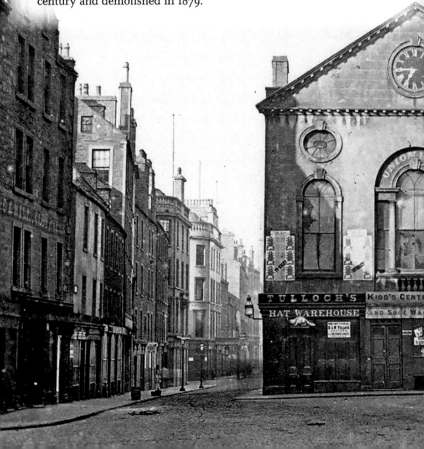

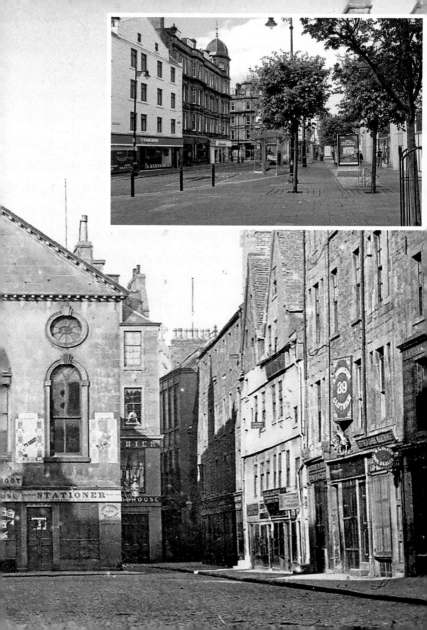

6. WHITEHALL STREET

It was long claimed Whitehall Street had been the site of a royal palace but this is disputed by modern historians. One monarch, at least, did visit the street though. It is decorated here for the visit of George V in 1914. The west side of the street was long dominated by Draffens department store (here Draffen & Jarvie) and the south by the Gilfillan Memorial Church, which survives today.

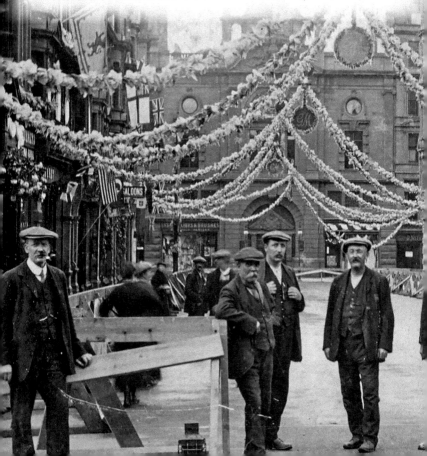

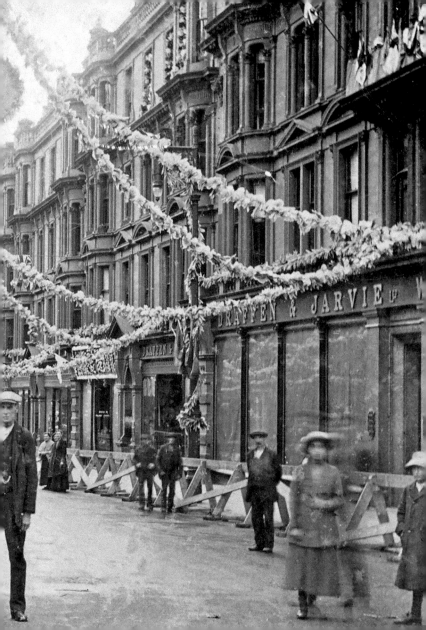

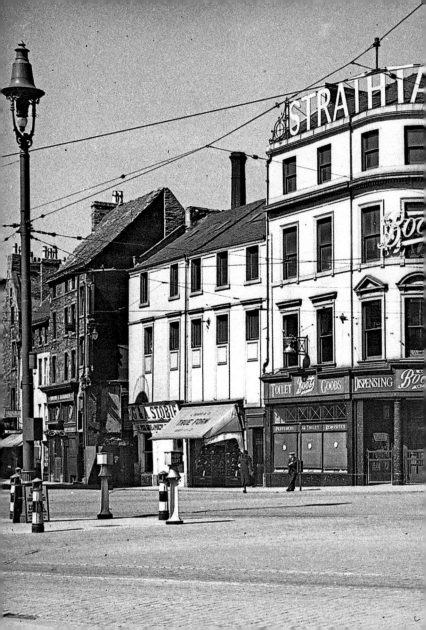

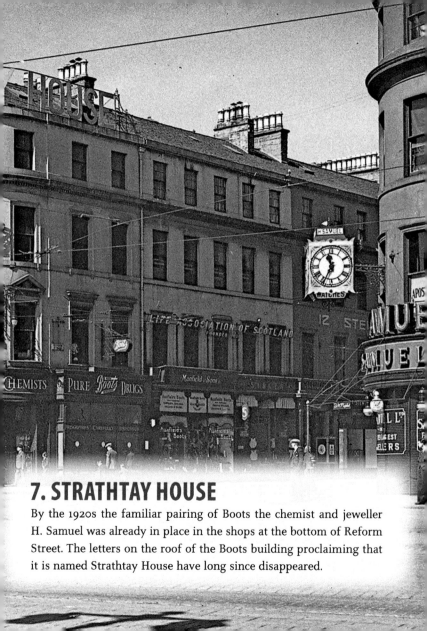

7. STRATHTAY HOUSE

By the 1920s the familiar pairing of Boots the chemist and jeweller H. Samuel was already in place in the shops at the bottom of Reform Street. The letters on the roof of the Boots building proclaiming that it is named Strathtay House have long since disappeared.

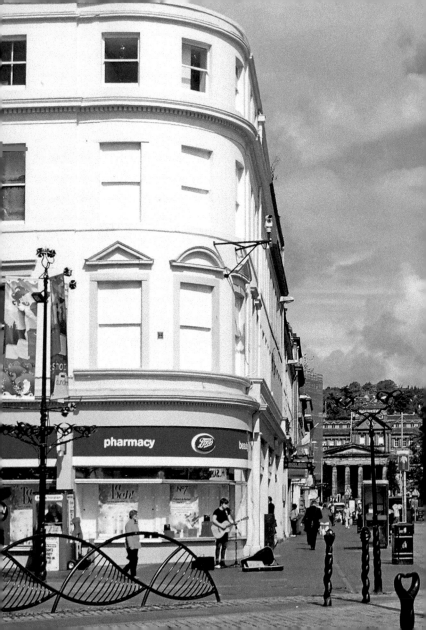

8. REFORM STREET

Named after the Great Reform Act of 1832, which increased the franchise for parliamentary elections, Reform Street was designed by the architect George Angus and provided a route northward from the High Street to the town's meadows and the High School of Dundee, which was also designed by Angus.

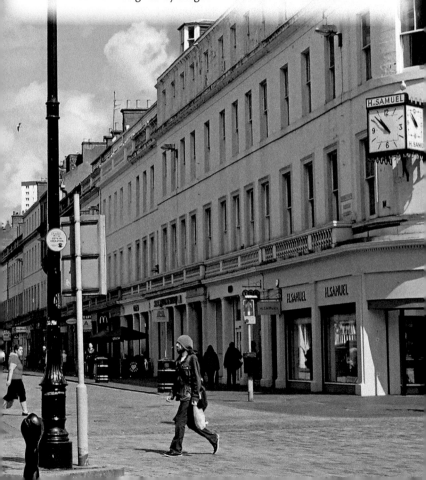

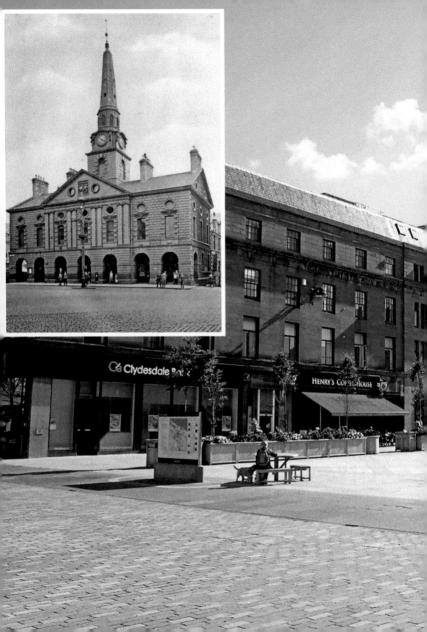

9. CITY SQUARE

For almost 200 years, the William Adam-designed Town House dominated Dundee's High Street and provided a meeting place for the town's politicians inside and another for its population outside underneath the colonnade (known locally as 'the Pillars'). Despite protests at its demolition and calls for it to be rebuilt elsewhere, the Town House was replaced by the City Square in the 1930s.

10. HIGH STREET

This old lantern slide shows the Town House in context and depicts the High Street at a time when the only traffic was of the horse-drawn variety. For much of the twentieth century the street was dominated by more powerful vehicles, but recent years have seen the area between Castle Street and Crichton Street entirely given over to pedestrians.

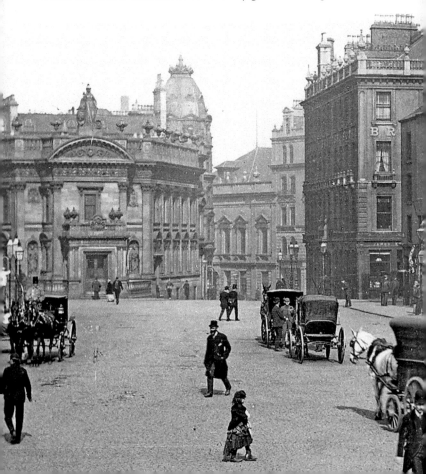

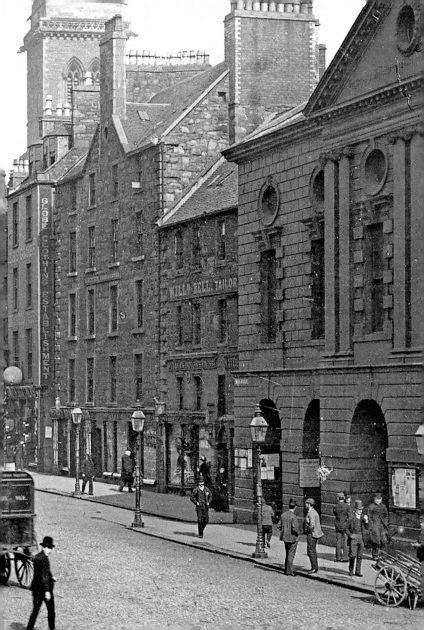

11. TRADES HALL

The Trades Hall occupied the east end of Dundee's High Street for a century and was home to the Nine Incorporated Trades of Dundee: the associations of Baxters (bakers), Cordiners (shoemakers), Skinners (glovers), Tailors, Bonnetmakers, Fleshers (butchers), Hammermen (metalworkers), Weavers and Dyers. Prior to this, their meeting place had been the Howff graveyard. The building was demolished in 1878 and its successor, formerly the Clydesdale Bank building, is visible at the rear of the Trades Hall in this view.

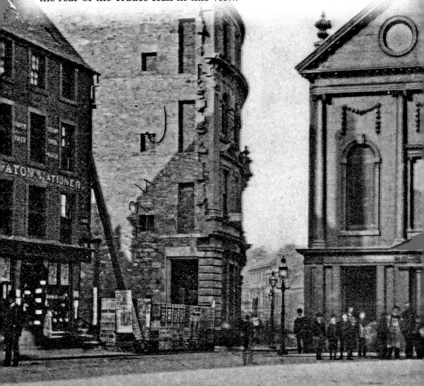

Old Trades Hall, High Stree

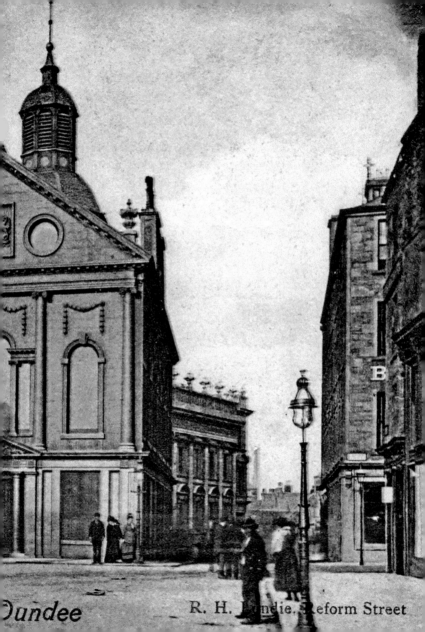

Dundee R. H. Lundie, Reform Street

12. ROYAL BRITISH HOTEL

The Royal British Hotel building at the corner of High Street and Castle Street, seen here in the 1930s, dates from 1842. It operated as a hotel until 1965 when it became the Dundee University's Chalmers Halls of Residence, taking its name from James Chalmers (1782–1853), inventor of the adhesive postage stamp, whose shop was once nearby. The building also houses J. A. Braithwaite's tea and coffee shop (established in 1868 and on this site since 1932).

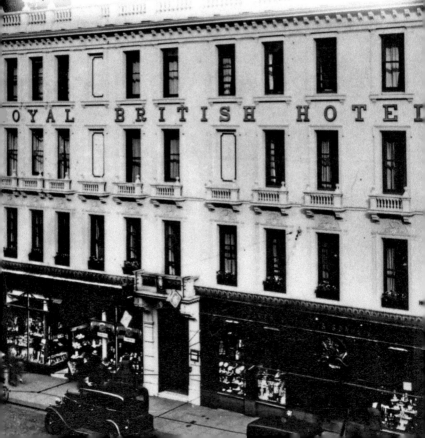

13. MURRAYGATE AT HIGH STREET

Demolition of the Trades Hall and old buildings in the Murraygate allowed the street to be widened at its junction with the High Street. This scene is largely unchanged today, though at the time this picture was taken photography was clearly still novel enough to attract attention. The most interesting addition in recent years is the statue of a dragon, which, according to local legend, met its death near Dundee.

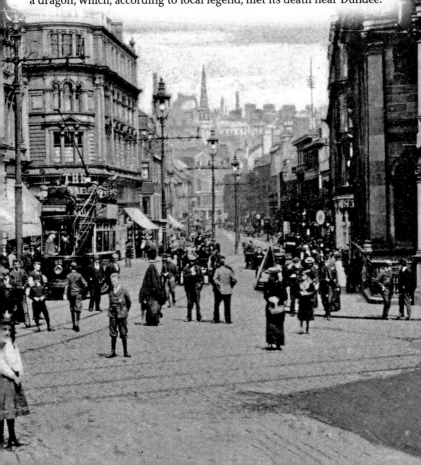

14. D. M. BROWN

David Millar Brown was born in St Ann Street, Lochee, in 1864 and was apprenticed to a local draper. In 1888 he established a business of his own in Dundee High Street. Over time, he acquired the surrounding properties until he had established one of Dundee's largest department stores, which included an arcade and restaurant and employed more than 500 people. In recent years, the process has been reversed and the building once again comprises of smaller shops.

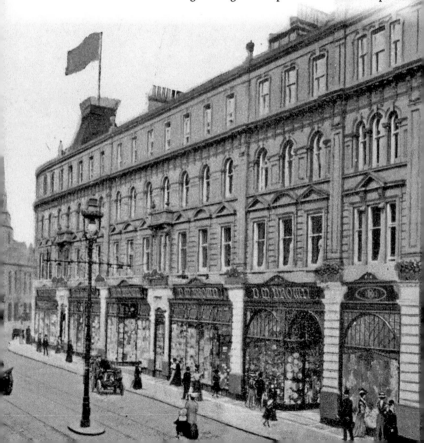

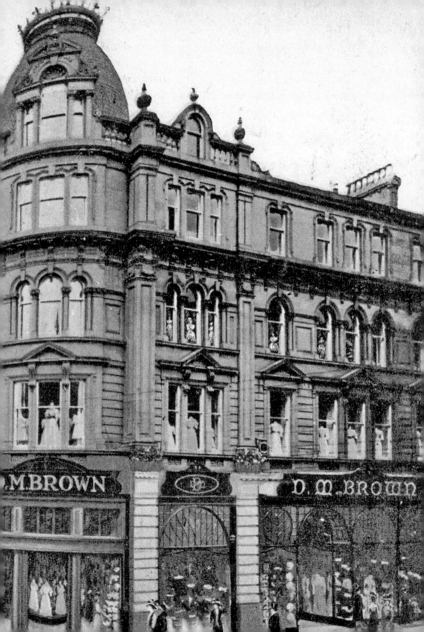

15. COMMERCIAL STREET

These children would be ill advised to stand in this position today as Commercial Street is one of the few streets in the heart of the city still open to traffic. South of where they are standing at the junction with the Seagate was an area once known as the Burnhead, marking where the Scouring Burn and the Dens Burn, which powered some of Dundee's earliest industries, met before flowing into the Tay.

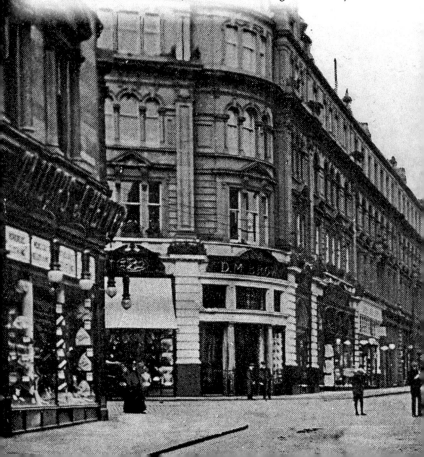

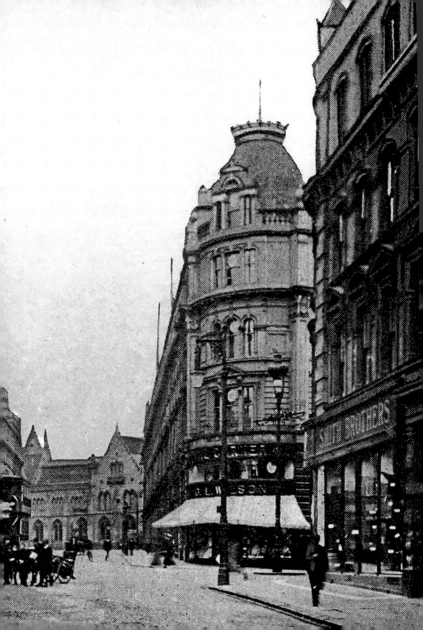

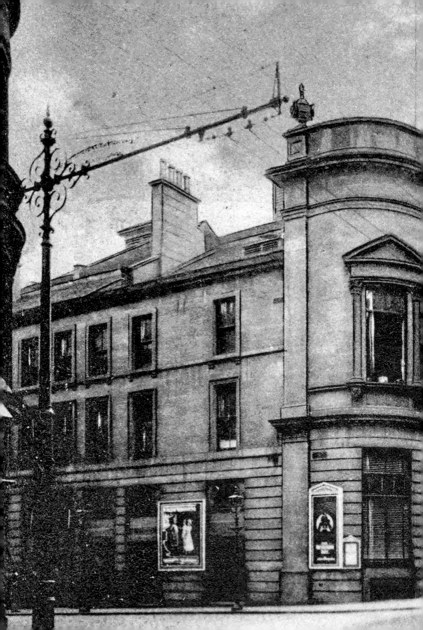

16. HER MAJESTY'S THEATRE, SEAGATE

Her Majesty's Theatre and Opera House opened at the corner of Seagate and Gellatly Street in 1885. It later operated as a cinema before being destroyed by fire in 1941. A new cinema, known as the Capitol and later as the ABC, took its place. At the turn of the millennium the building became a pub, which bears the name of the Capitol in tribute to its past.

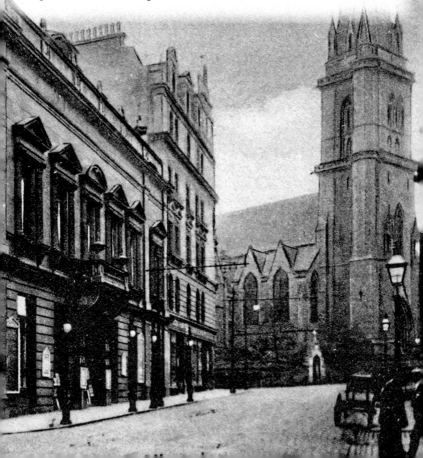

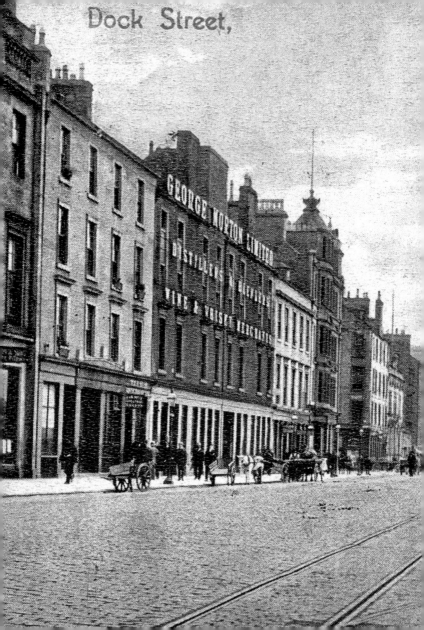

Dock Street,

17. DOCK STREET

It is testament to the shifting boundaries between Dundee and the River Tay that Yeaman Shore is not on the shore, the Seagate is not near the sea and Dock Street has no docks in it. This was not always the case, though, as this old postcard demonstrates. Dock Street may not have regained its docks but it is at long last regaining some prominence after decades in the shadow of the Tay Bridge approaches and Tayside House.

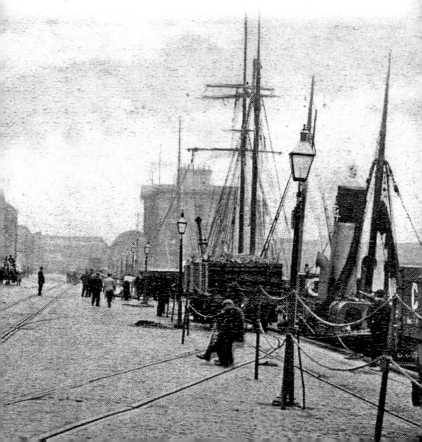

18. THE DOCKS

This view gives a good indication as to how central the docks were to Dundee. A visit to the same site today shows how the connection with the river has been lost in the years since they were filled in to accommodate the landfall of the Tay Road Bridge. An important part of the redevelopment of the waterfront area in recent years has been the attempt to restore that link.

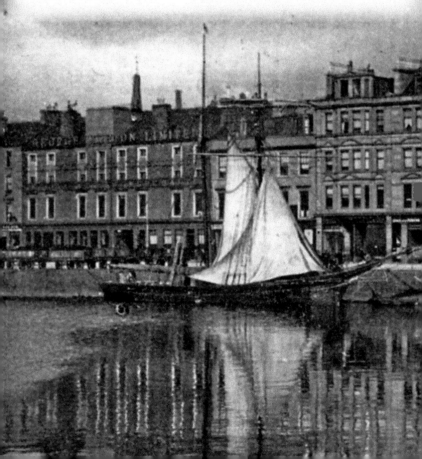

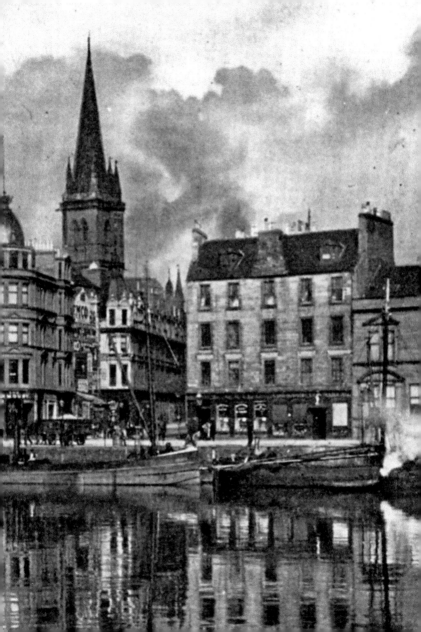

19. ROYAL ARCH

When Queen Victoria visited Dundee in 1844 a triumphal arch made of wood was erected for the occasion. In 1850, a more permanent stone structure was put in place, designed by John Thomas Rochead, who also designed the Wallace Monument. The arch was demolished in the 1960s to make way for the Tay Road Bridge but the survival of the Exchange Coffee House building gives a clue as to its former location.

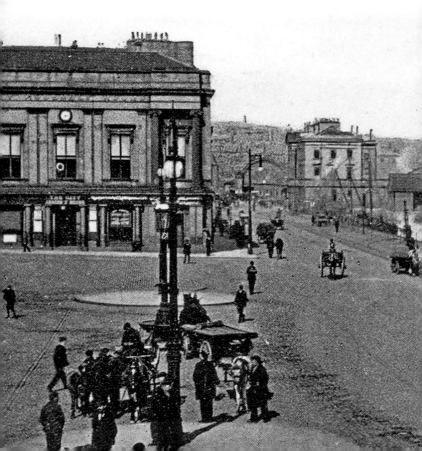

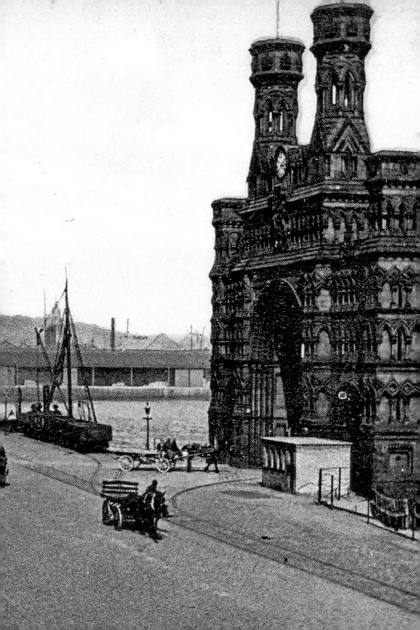

20. UNION STREET AND
WHITEHALL CRESCENT

Mathers Temperance Hotel opened on this landmark site at the junction of Union Street and Whitehall Crescent in 1899, a powerful symbol of the strength of the prohibition movement in the city at the time. The building was sold in 1969 and was later known as the Tay Hotel. In more recent years it fell into disrepair before being refurbished and reopened in 2014 as the Malmaison Dundee.

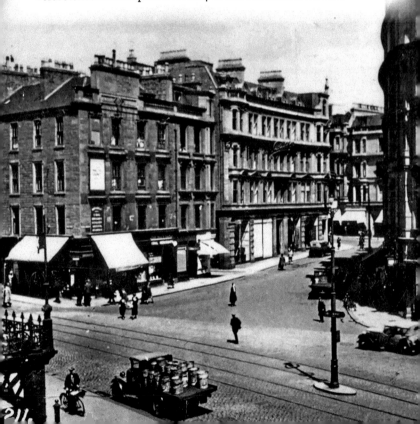

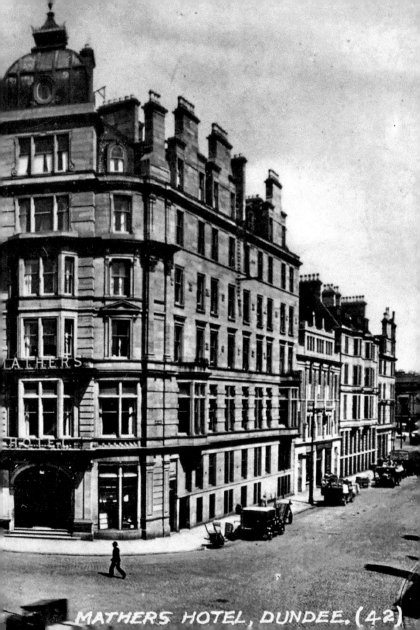

MATHERS HOTEL, DUNDEE. (42)

21. *DISCOVERY* AND THE V&A

The Royal Research Ship *Discovery*, which was launched in 1901, was built in Dundee for the British National Antarctic Expedition under Captain Robert Falcon Scott and was the first vessel to be constructed specifically for scientific research. After a varied career, she returned home to the city in 1986 and became one of Dundee's major tourist attractions. She has now been joined by another: the V&A Museum of Design.

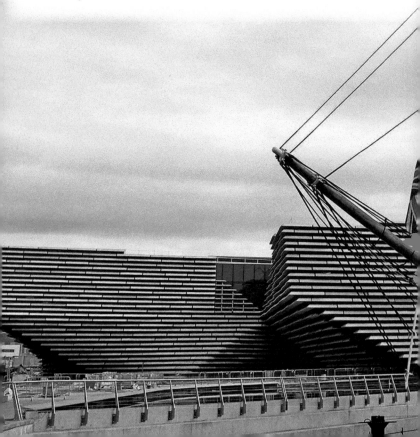

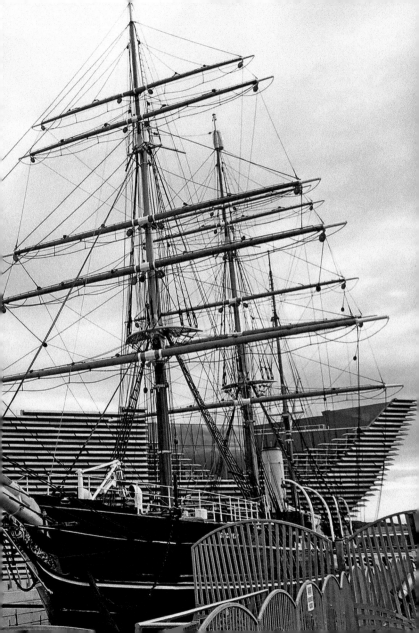

22. CROSSING THE TAY

For centuries the only way to cross the Tay at Dundee was by boat. A regulated ferry service began in 1713 and continued in one form or another until the opening of the Tay Road Bridge in 1966. Indeed, the last of the 'Fifies' set sail on 18 August that year, the day the bridge opened.

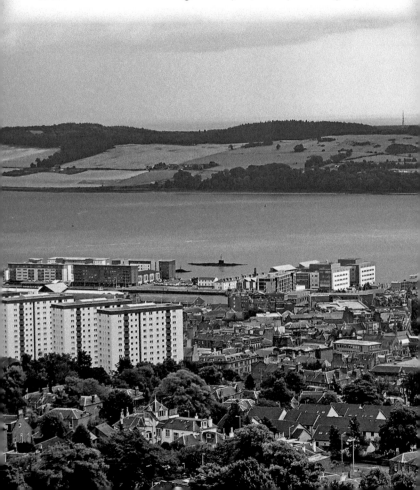

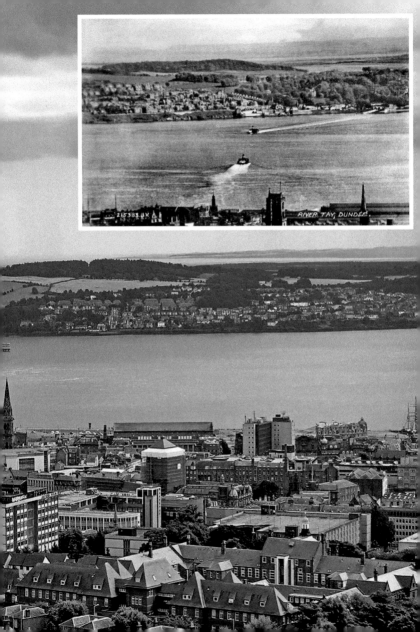

RIVER TAY, DUNDEE.

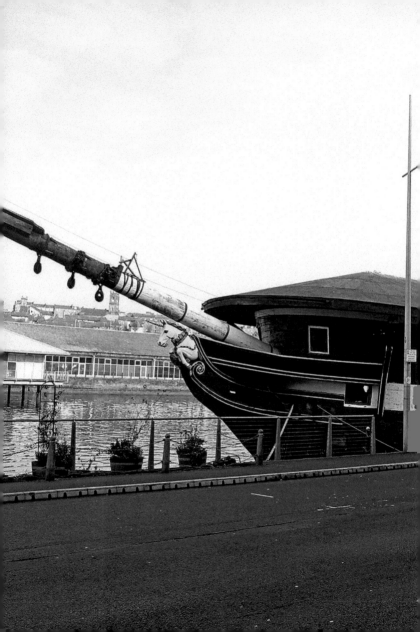

23. HMS *UNICORN*

While the *Discovery* is perhaps the most famous historic ship in Dundee, she is not the oldest. Launched in 1824, HMS *Unicorn* was built for the Royal Navy in the Royal Dockyard at Chatham and is now one of the oldest ships in the world. Situated at Victoria Dock, she is open to the public and well worth visiting.

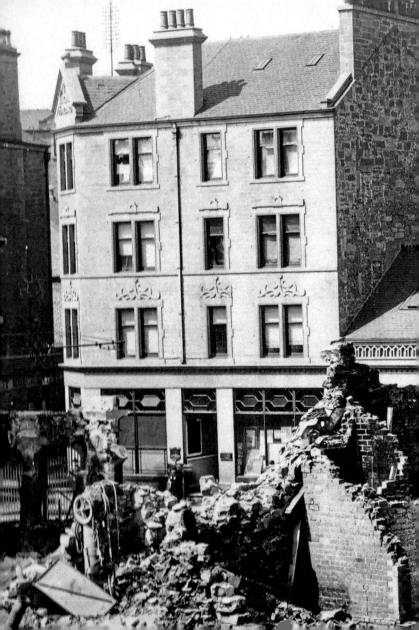

24. SEAGATE

From the earliest days of the burgh until the town's centre shifted westward to the site of the present-day High Street, the Seagate was Dundee's main street. This picture was taken in 1906 through the rubble of Watson's Bond, the scene of Dundee's greatest fire, which caused around £400,000 of damage.

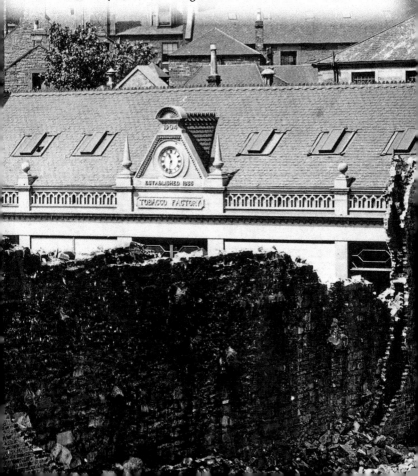

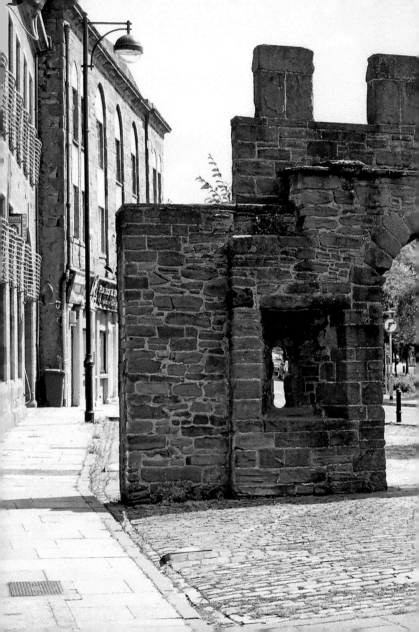

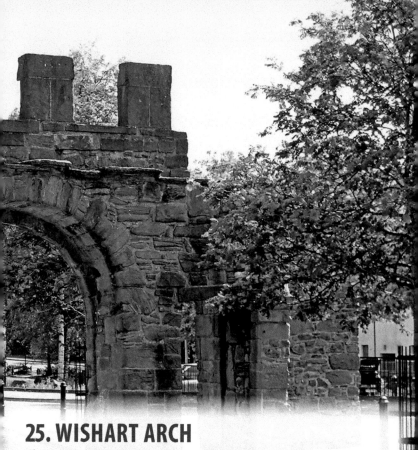

25. WISHART ARCH

The Cowgate Port is the only one that survives of the ports or gates that once punctuated Dundee's walls. Tradition has it that during the plague of 1544, the Protestant reformer George Wishart preached from this port to the plague stricken in the 'sickmen's yairds' outside the town. Though Wishart did visit Dundee during the plague, this structure is thought to date from the 1590s, half a century after Wishart's death.

26. ST ROQUE'S LANE

In former times this view was referred to as Heaven and Hell, with the Wishart Church where renowned missionary Mary Slessor once worshipped upstairs and the John O'Groats public house (concerned with a different kind of spirit) downstairs. Both have proved to be less than eternal though, and while the building remains, both levels have since been put to other uses.

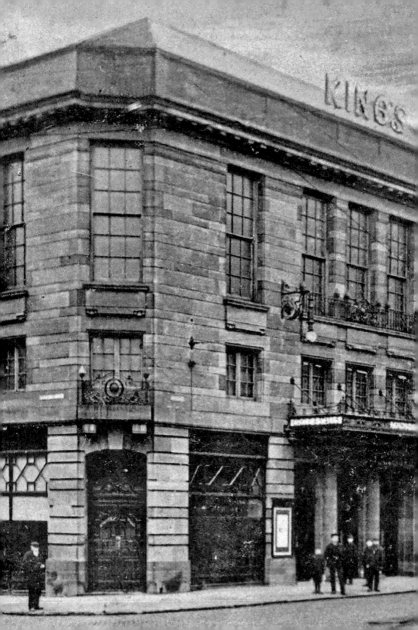

27. KING'S THEATRE, COWGATE

The King's Theatre and Hippodrome opened in 1909 and was used mainly for plays and variety shows. In the 1920s it became a cinema and was later known as the Gaumont and the Odeon before closing its doors in 1981. In the years since, the building has been used as a bingo hall, a bar and a nightclub, though many have campaigned for its restoration and return to use as a theatre.

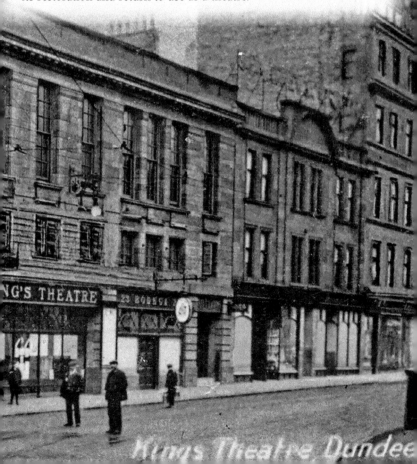

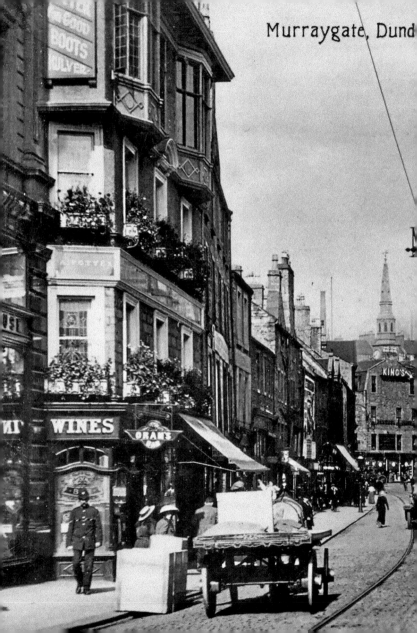

Murraygate, Dund

28. MURRAYGATE

One of the oldest streets in Dundee, the Murraygate is thought to have been named after Thomas Randolph, Earl of Moray, who fought alongside Robert the Bruce at the Battle of Bannockburn in 1314. The street itself, though, was probably already in existence before this. In more recent years it has been known as Dundee's first pedestrianised shopping street and is easily distinguished by the tramlines, which can still be seen here but were removed elsewhere after the trams stopped running in 1956.

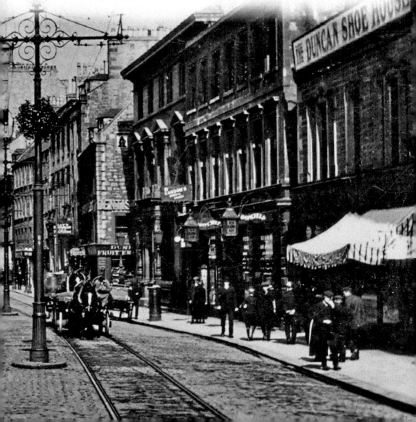

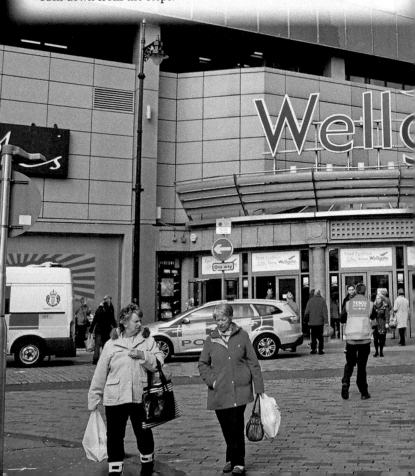

29. WELLGATE

The Wellgate Shopping Centre, built in the 1970s, has obliterated all trace of the historic street that previously bore the name. The old Wellgate rose from a point at the left-hand side of the view in this photograph to the steps at Victoria Road. The earlier picture looks back down from the steps.

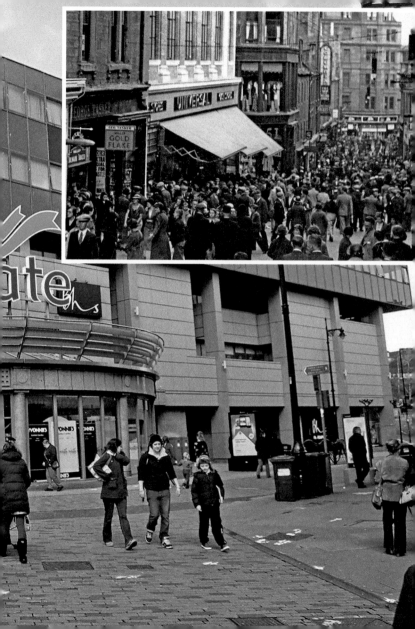

30. WELLGATE STEPS

The Lady Well, which for centuries provided Dundee's principal source of drinking water, was once situated in this area and is commemorated in the name of the Ladywell Tavern and indeed the Wellgate itself. The original Wellgate steps shown in this 1920s scene suffered the same fate as the street itself but were later replaced. The Victorian lamppost survives and acts as a good point of reference today.

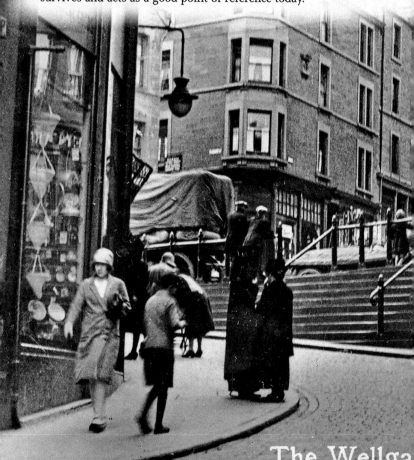

The Wellga

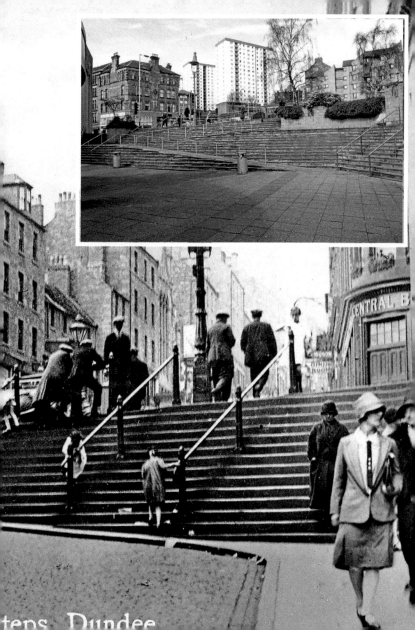

...teps Dundee

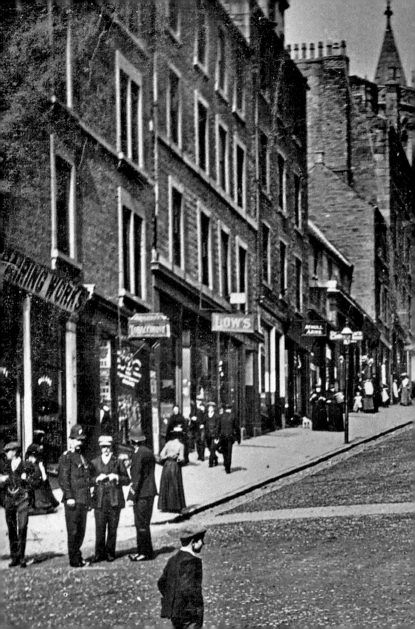

31. THE HILLTOWN

Once a separate barony outside the burgh of Dundee, the Hilltown was purchased by the town in 1697. By the time this photograph was taken in the early years of the twentieth century it was a densely populated, bustling suburb. More recently, demolitions of old tenement properties have given the area a more sparse appearance, though it remains well populated and includes some of the few multistorey blocks remaining in Dundee.

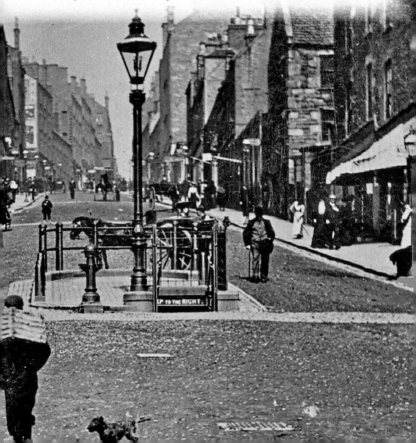

32. PANMURE STREET

Panmure Street was the first part of Dundee's ancient Meadowlands to be developed and contains the Royal Exchange Building. Plans for an elaborate crown to top its tower had to be abandoned when it began to sink into the marshy ground. The nearby statue of Queen Victoria was unveiled in 1899 to mark her diamond jubilee.

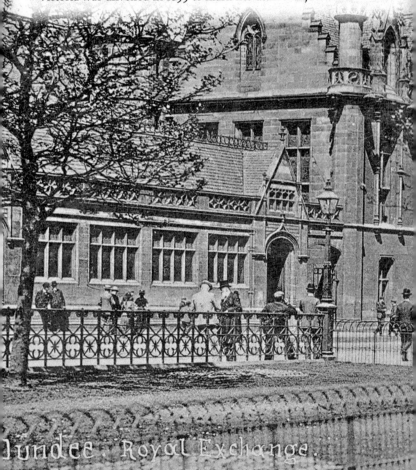

Dundee. Royal Exchange.

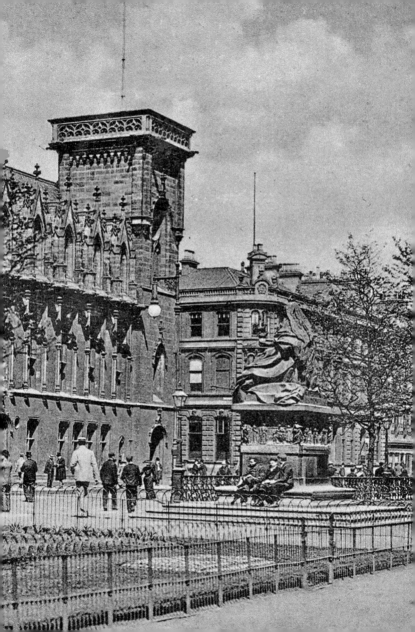

33. McMANUS GALLERIES

Built in 1865–67 to a design by George Gilbert Scott, the Albert Institute (later renamed in honour of former Lord Provost Maurice McManus) originally housed Dundee's Free Library before an extension was completed in 1872 containing a museum and art gallery. The Robert Burns statue (unveiled in 1880) completes a familiar scene.

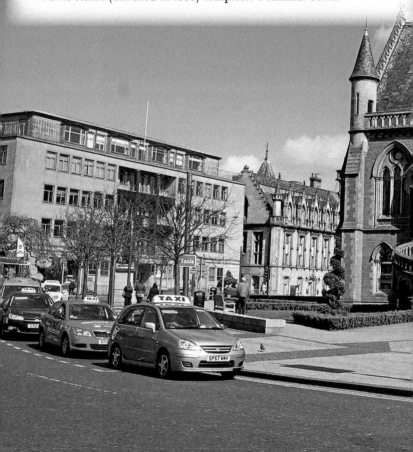

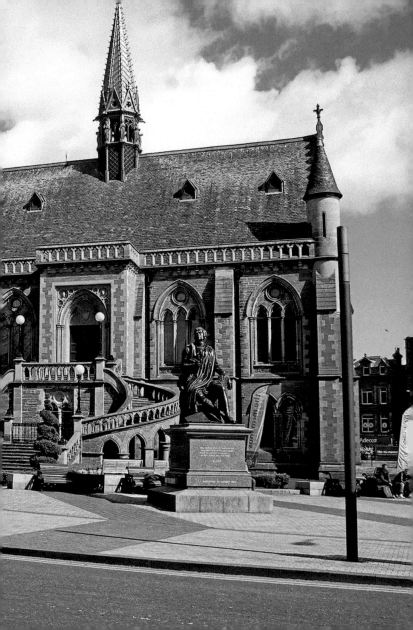

34. THE HOWFF

In 1564, Mary, Queen of Scots gifted part of the grounds of the pre-Reformation Greyfriars Monastery to the town of Dundee as a place of burial. The graveyard served as a meeting place or 'howff' for the Incorporated Trades of Dundee for almost 200 years and it retains the name today. It contains many old and interesting gravestones.

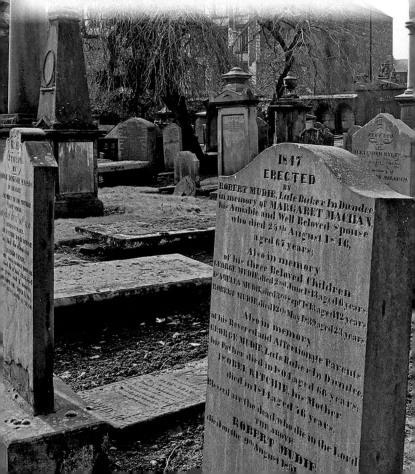

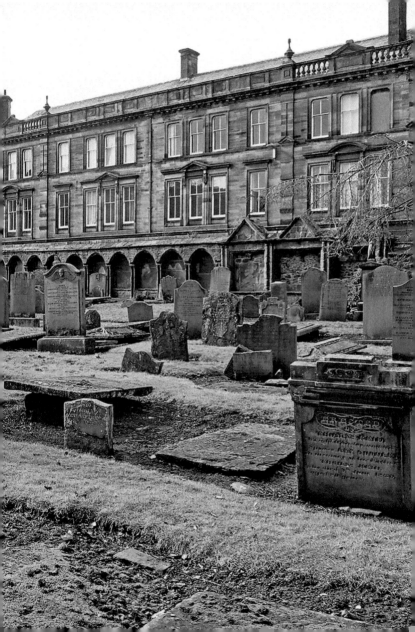

35. CONSTITUTION ROAD

Constitution Road rises steeply from the city centre up the slope of the Law, though its path is now interrupted by the North Marketgait section of the inner ring road. The French Renaissance-style building on the right formerly housed the General Post Office and dates from the late nineteenth century.

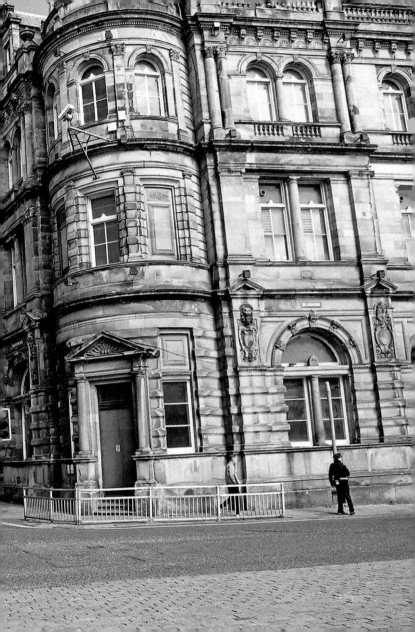

36. LAW HILL

Carry on up Constitution Road and you will eventually reach the summit of Dundee Law. It is well worth taking the detour, either on foot or by car (there is a road to the top), for the magnificent views over the city and beyond. Despite 'law' itself being a Scots word for hill, Dundonians (the author included) persist in calling this extinct volcanic plug (seen here from Lochee Park) the Law Hill.

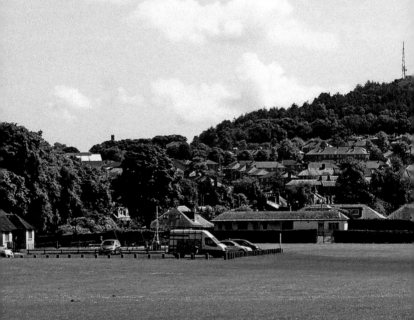

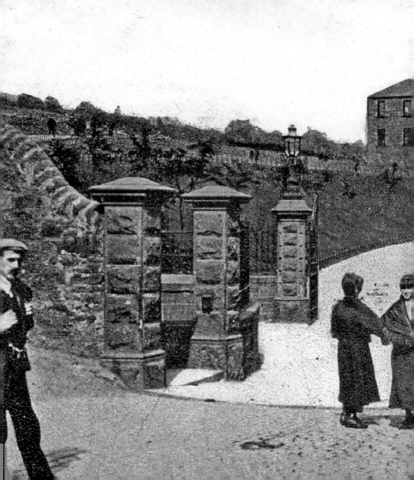

Entrance to Barrack Park, Dundee

37. DUDHOPE PARK

The town council leased the part of Dudhope Park above the castle as a recreation ground – known as Barrack Park – in 1854. Following the departure of the army, the whole grounds including the castle were purchased and opened as a public park in 1895.

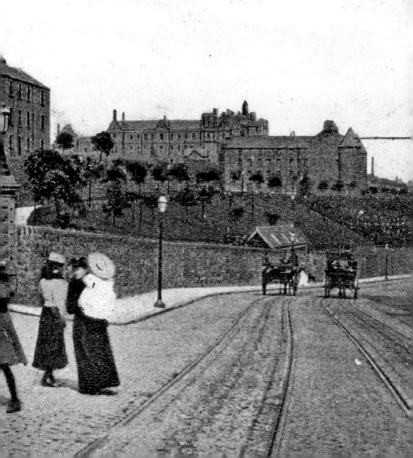

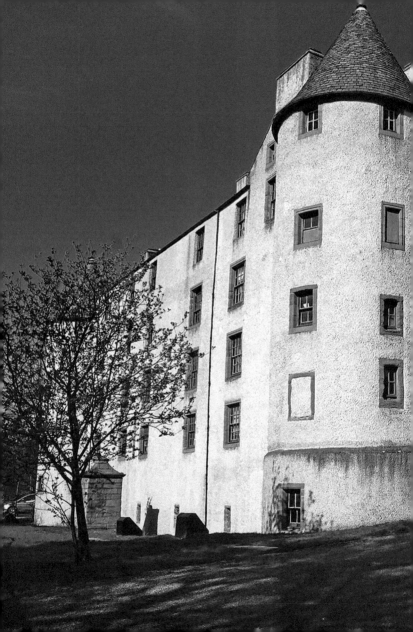

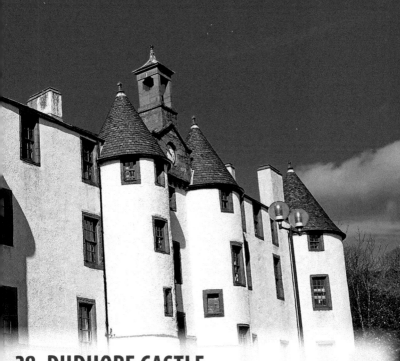

38. DUDHOPE CASTLE

Dudhope Castle dates from the late thirteenth century and was the home of the Scrymgeour family, the hereditary Constables of Dundee. Later occupants included John Graham of Claverhouse ('Bonny Dundee' or 'Bluidy Clavers'). The present building was constructed in the sixteenth and seventeenth centuries. For almost 100 years until 1880 and again during the two world wars the castle was used as a barracks. The building later fell into disrepair but was restored in the 1980s.

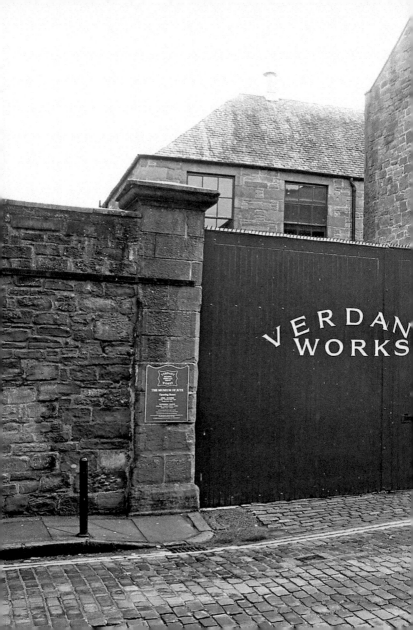

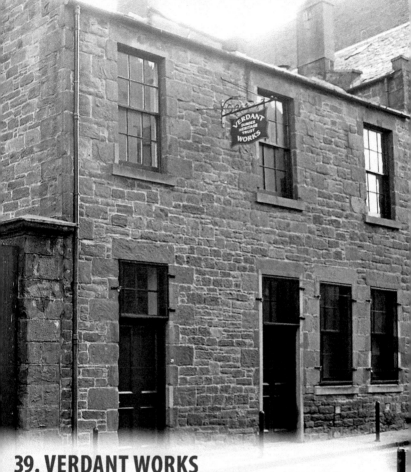

39. VERDANT WORKS

For much of the nineteenth and twentieth centuries, Dundee was dominated by the jute industry. Verdant Works opened in 1833 and like many of the earliest mills was drawn to the area around the ready-made power source of the Scouring Burn. The burn is now piped underground but Verdant Works has been fully refurbished as a visitor attraction that tells the story of Dundee's textile heritage.

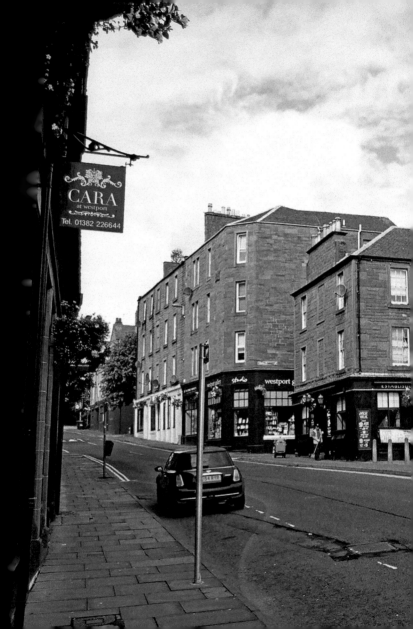

40. WEST PORT

The West Port was originally one of Dundee's historic gateways, but while the gate itself was demolished in 1757, the name was retained for this area – the ultimate destination of the Overgate before the advent of the shopping centre and the road left the two as separate entities. The Hawkhill (now renamed Old Hawkhill) is on the left of the picture, while the road on the right (once a continuation of Brook Street) is now known as Hawkhill.

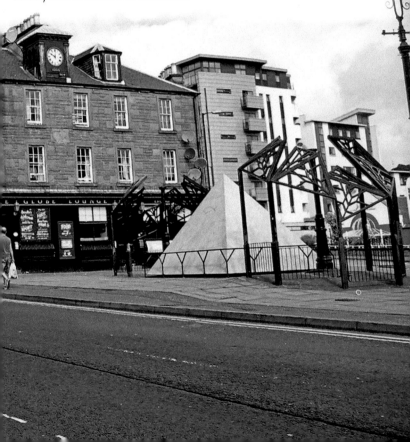

41. CAIRD REST

Originally a private residence, Caird Rest was donated to the community by jute baron Sir James Key Caird, who also gave the city Caird Hall and Caird Park. It opened in 1912 'for the purposes of a place of rest and recreation for aged persons'. It was later used by Dundee University and is now the restaurant 172 at the Caird.

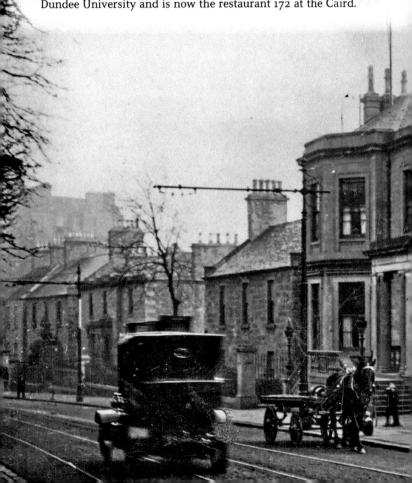

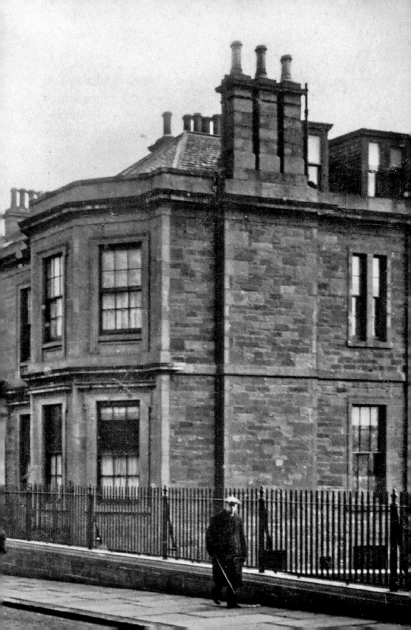

42. PERTH ROAD

The family firm of James Aitken & Son occupied premises at the corner of Perth Road and Miller's Wynd for more than a century from 1874. Indeed, the business occupied a shop on this site before the tenement shown here was built. As Aitken Wines it still operates today from premises in Annfield Row and Broughty Ferry while the Perth Road shop is home to the Tartan Coffeehouse.

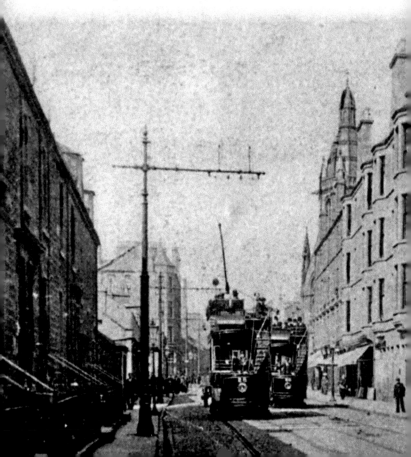

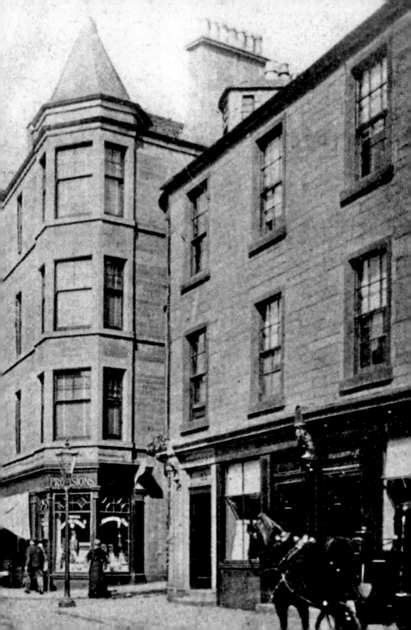

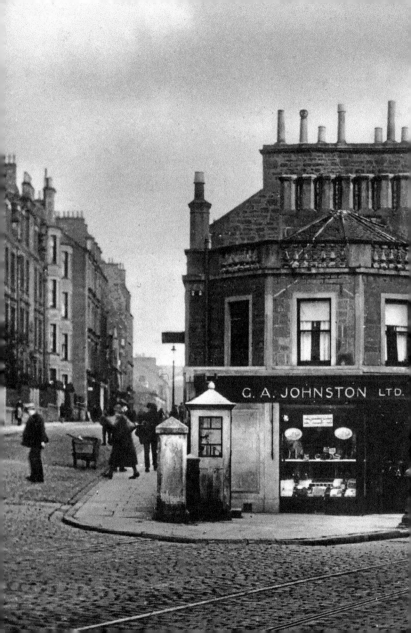

43. SINDERINS

The point at which the Perth Road and the Hawkhill either part from each other or come together, depending on your point of view. The fact Dundonians have given this area the name Sinderins from the Scots word 'sinder', meaning 'to part' (like its English equivalent 'sunder'), means that officially at least this is the parting of the ways.

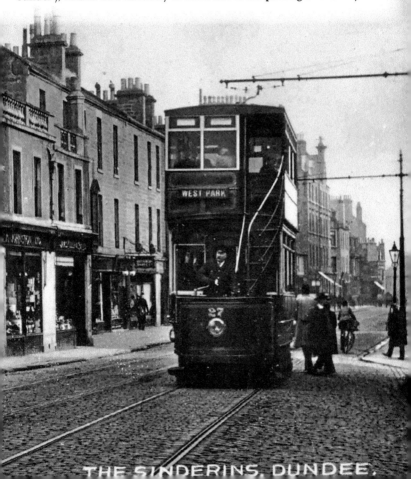

THE SINDERINS, DUNDEE.

44. BLACKNESS LIBRARY

The Dunfermline-born industrialist and philanthropist Andrew Carnegie's Trust provided the funds for several branch libraries in Dundee including this magnificent one at Blackness, which was designed by the city architect James Thomson and is still in use more than a century after it opened.

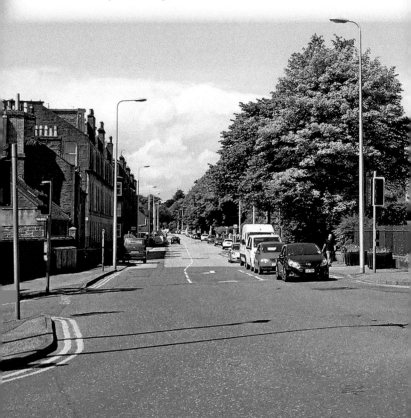

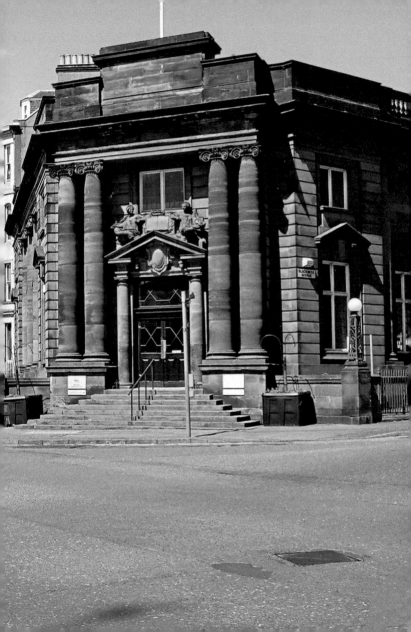

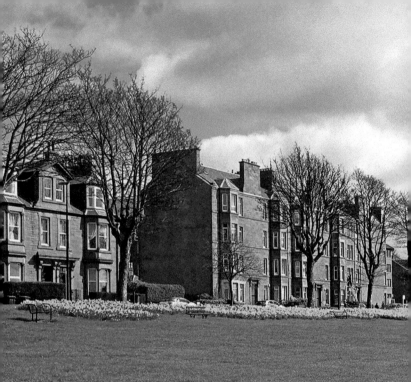

45. MAGDALEN GREEN

The name of Dundee's oldest public park is said to derive from a chapel dedicated to St Mary Magdalen that once stood in the vicinity of the present-day Step Row. Magdalen Yard or Green once extended to the river before the intervention of road and railway. Still a popular place of recreation, its most distinguishing feature remains the fine Victorian bandstand, which was erected in 1890.

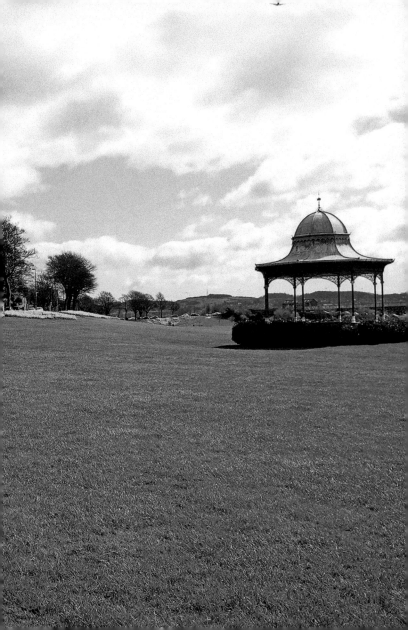

46. TAY BRIDGE

Designed by Thomas Bouch, the Tay Bridge opened in 1878 and was regarded as a triumph of Victorian engineering. Tragically, it collapsed on 28 December 1879, taking with it a train and all seventy-five passengers and crew. Bouch's reputation never recovered and he died less than a year later. The present bridge designed by William Henry Barlow was opened in 1887. The piers of Bouch's bridge remain visible – a poignant reminder of the tragedy.

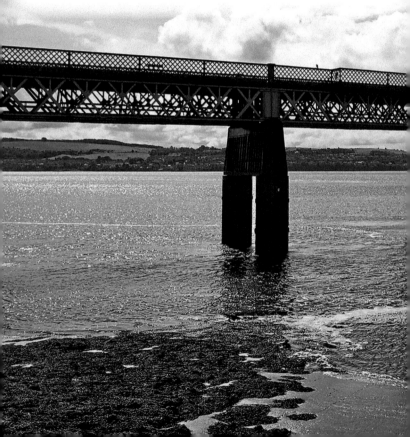

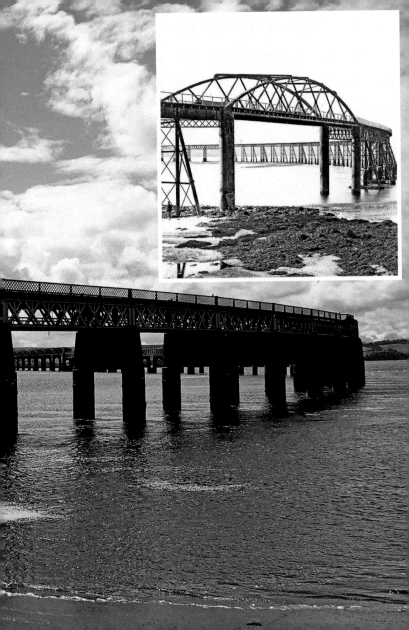

47. ESPLANADE

Dundee's Esplanade was constructed in stages in the late nineteenth century on land reclaimed from the River Tay. The section from the ferry terminal at Craig Pier (at the modern-day Discovery Quay) to the Railway Bridge soon became a popular walk as can be seen in this Edwardian photograph and it remains so today.